The Skies
of Peace and Passion

Sky Paintings and Poems

by

Jeni Bate

Marilyn
Enjoy the poetry
and the clouds and
being Welsh!!
Jeni Bate

"I paint the skies
 with peace and passion,
because that's the way
 they paint me."

Jeni Bate

This book is a collection of poems and paintings, inspired by life, and the skies that remind me how small that life is, yet how wonderful it is to be able to use that life to appreciate a big sky.

I have written poetry since childhood - a strong cultural influence of my birth country Wales. Perhaps it reflects the trials of life in that place - LA poet Jerry Hicks once said he believed all poets had one thing in common - a traumatic event that affected them. I also heard another poet at a poetry reading at Coffee Cartel in Redondo Beach refer to the practice as 'The medicine of the pen'.

The Welsh are poets, not painters, but painting was also a childhood passion. And not just painting, but painting skies. I remember the mix of delight and disappointment when receiving paint-by-numbers sets as a gift - I always seemed to get one at Christmas. There were landscapes and seascapes, even cityscapes, but I wondered - why are there no skyscapes? Recently an early photograph of me surfaced - a slide. I must have been about four. My mother photographed me painting at my little easel. The painting I have completed is a sky.

There are three people who had a particular influence in this book who are not mentioned on an individual page, Eric von Mizener, a fellow poet, who was brave enough to take on the task of editing, Christina Lange for helping me to overcome the technical hurdles that stalled this project for three years, and Duke Ackerman who kept bugging me about it enough to keep trying. Thank you, all of you.

Jeni

Difference

What is it like to be you?
If I were you,
I would not know
What it is like to be me
To know the difference.

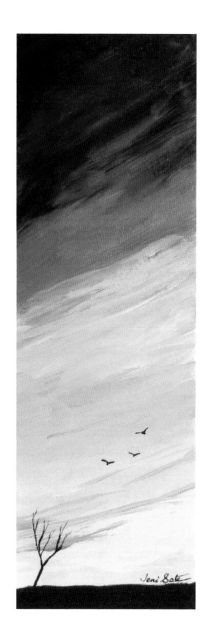

"Wait for Me"

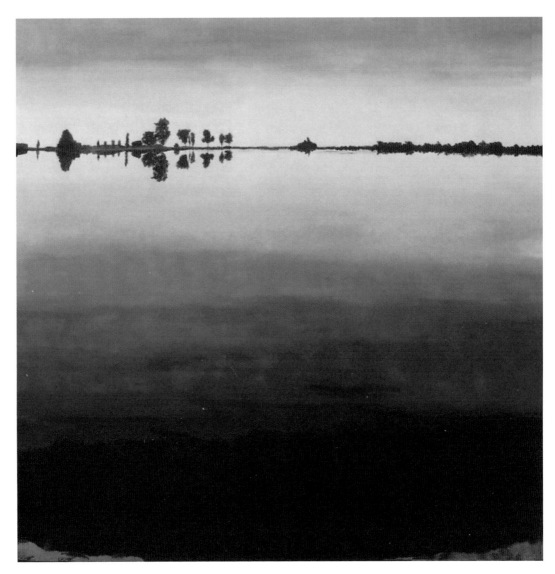

"Wiest Lake"

Puddle

|f you think that |
am shallow
or superficial
as a rain puddle
consider that
when the clouds
have run away
| am as deep as
the blue sky
and can show you

your own face
as others see it

Two Men

The man inside the man in front of me,
The one I fell in love with long ago,
The one I stayed around to get to know,
The one I loved before he noticed me,
Got hidden 'neath insanity's red shrouds,
Became a dragon breathing words that burn
Down to the bone, and every way I turn
There is no soothing rain, only more clouds.
I run away, but still love draws me close.
I fear his fire, yet long to hear his heart.
To be together tears us both apart -
Life with him or without him is morose.
 I cry at memories, yet long to see
 The man inside the man in front of me.

"Sea Crest Dawn XXIX"

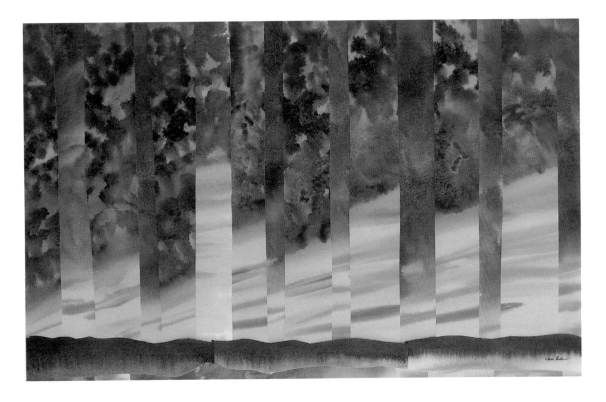

I learned about Shakespearean sonnets at school and love to write in this form. I hope to one day write more sonnets than Shakespeare himself, though I suspect I have already written on a wider range of topics.

"Red Zipper"

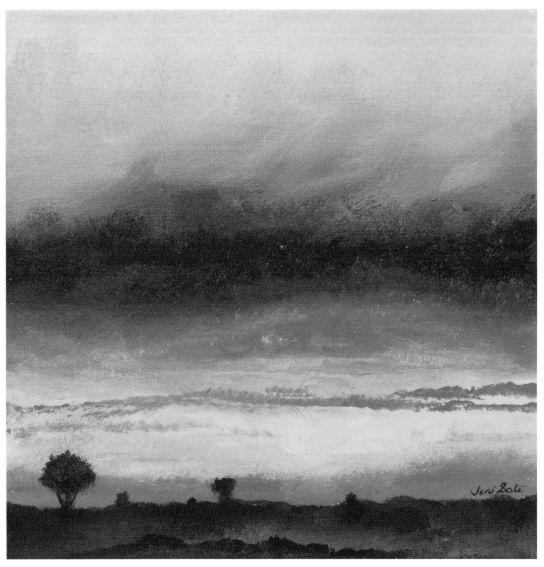

The sound of a car alarm is so common these days, it has become background noise. No one notices them any more, partly because they go off at the littlest thing. A cat walks by, and the alarm goes off. What if, instead of honking and beeping, they read a poem?....

Shakespearean Sonnet of Car Alarms

There's something that I really need to say
A thief is trying to drive this car away!
He'll break my window, rip ignition wires
And then I'm sure he'll make me squeal my tires.
He'll rev my engine, drive me really hard
Round corners and through somebody's front yard.
I fear I'll go the wrong way up the street,
Hit people who aren't hasty on their feet
Then cops will chase me with their flashing lights
And corner me with sturdy black and whites
Who'll pit me so I spin into a wall
And then I won't feel very well at all.
 And I can't see this thief - I have gone blind
 Oh, it's a gust of wind, oh, never mind.

Making Love in the Rain

The rain, the rain
The jealous rain
Tries to get in through the
window
Wants to be a steamy part of
the passion
That we are always
Midsummer hot
Roiling

The bed a cauldron
Without need for fire
Heaving with storm
The ocean the rain runs to
Salty
Boiling until we are dry
And covered in sweat

And the rain, the rain
The screaming rain
Still trying to get in
Wanting to be the drops
That ooze from our pores

Or maybe the clamoring
Is applause.

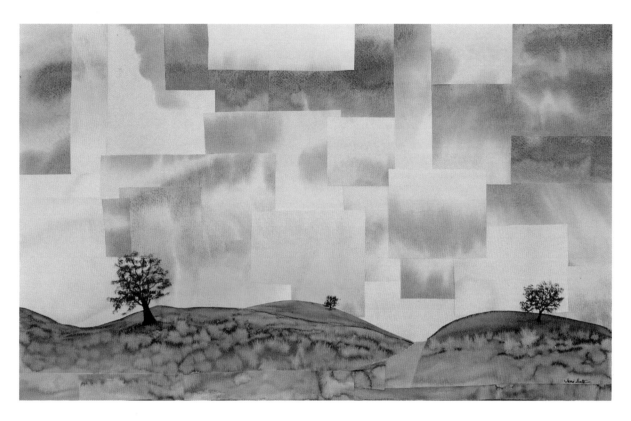

"Dawn over Heather"

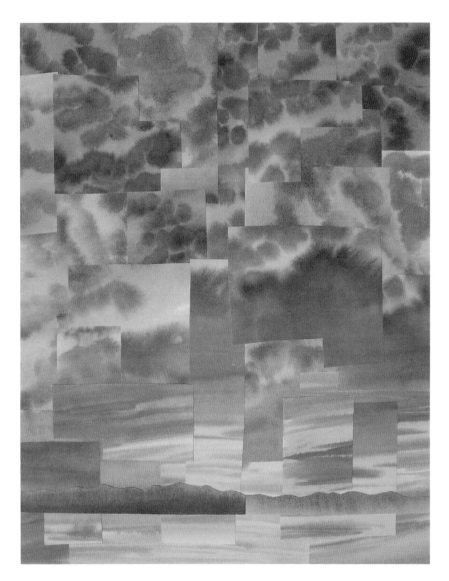

"Sea Crest Dawn XXXIII"

Water Gods

Wild secrecy, dark raging pool
With undercurrents I cannot see
Surface of deep reflection, spiked
With drops that fall from tumult skies
Sometimes a few, sometimes a storm
So hard I cannot see my face

Wild secrecy, you pull me down
To depths I cannot comprehend
Or breathe, why should I breathe the air
Your soft dark gentle folds, your hands
Still draw me in to flow with you
So hard I cannot see my soul

Wild secrecy, deep rocky lake
Of unknown whirlpools hidden in
A surface dark as starless skies
Do not resist this downward thrust
I am the ocean waiting here
Let go and run back down to me.

Learning Curve

The clock, almost in tune with nature
Goes round and round and nowhere anyfast
Always the speed of the earth

Never the pace of the world
Which divides up the day.
We measure time and never know its value.
How long is a second?
Should it be the length of a heartbeat?

Does the heart beat out
The life it was allotted
At a slower or faster place
Why do we all wish for more time
Yet never seem to enjoy it
Ticking away future into past
Into spirals into circles into curves

Lost we have lost
The empty moments
The feeling of stillness
That the next moment will happen

"Sea Crest Dawn XX"

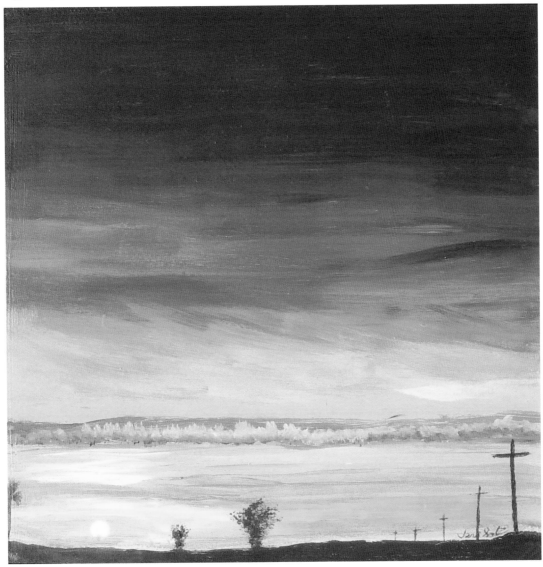

Regardless of numbers
Is time just a matter of distance
Are we running away from ourselves
The shortest distance between two points
Being the curve that is part of a dial
When do we go home to our hearts?

Lives always go off at tangents
We learn and learn and fail to know
The enormity of knowledge we can never achieve
The gradient becoming ever steeper
Yet we hold on with ropes and clips and pitons
To the inside of this ever expanding balloon
Fearing the gravity of ignorance
Never thinking we may learn in freefall
The final wisdom of flight

I know a man who has a clock
Whose hands lie at the bottom of the dial
He winds it every dawn when the freeway traffic
wakes him
To remind himself
Of those feelings he cannot name

A lesser man would have thrown it away.

"Shepherd's Warning"

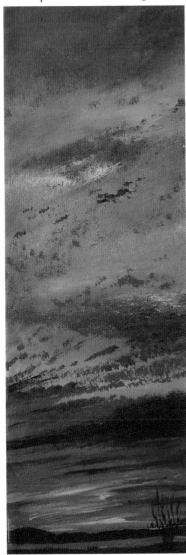

Solitary Daffodil

As I walked down a storm-drenched street
I saw in someone's garden bed
A daffodil raise its brave head
Against the unrelenting wind,
The driving rain that soaked my feet,
A match the flower could hardly meet.
And yet the wind beat hard in vain
Against that trumpet, yellow finned
An eyeless face that almost grinned.
The daffodil would stand, was set,
Determined the wind would not gain
An unfair overhand with rain.
As I walked up again, I found
That daffodil was standing yet -
The others round it all were wet
And being whipped to near the floor
Had snapped their stems and were not sound
So now lay helpless on the ground.
Each single one was beaten, save
The one on which I write this lore
That nods and bobs its head once more.
There's not much else that can be said
But that the cruel wind half forgave
The daffodil that was so brave.

"Old Moon II"

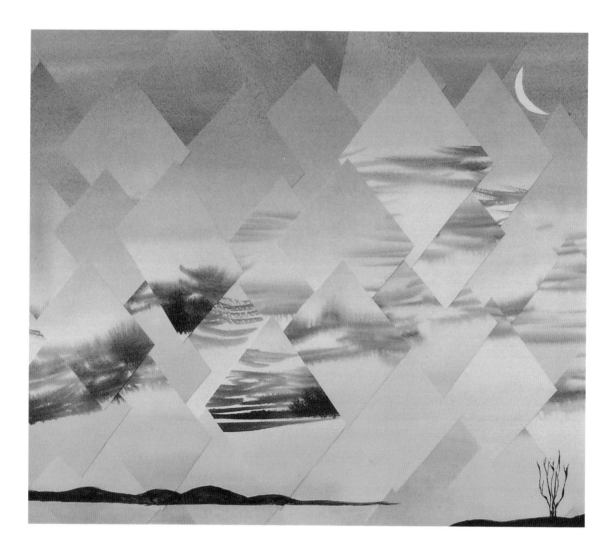

Cycle

This is all
this all we need

take a moment to consider ... atomic structure
take a moment to mourn ... the most cruel words
 your big sister ever told you
take a moment to celebrate ... really really good sex
take a moment to make ... someone
 else's footprints with your toes

this is all
this is all we need to complete

listen to music ... and see pictures
listen to words ... and see emotion
listen to emotion ... and dance
listen to numbers and colors ... and all they have to say

this is all
this is all we need to complete your soul

Completed a few Seconds before Sunrise.

Pink tinged clouds adorn the high horizon,
The sun still sleeps.

Gray wavelets lap along the lake's gray edge,
The white mist creeps

Forests of pine that clothe the mountain green
Are gray and still

The highest upland you can see is not
Mountain or hill

The lonely bell that rings seems to echo
From each high peak

Below, the boat's oars, dipping in the waves
Emit slow creek

The sun is nearly risen, this calm spell
About to break

The silence whispers sun's approach, the day
Almost awake.

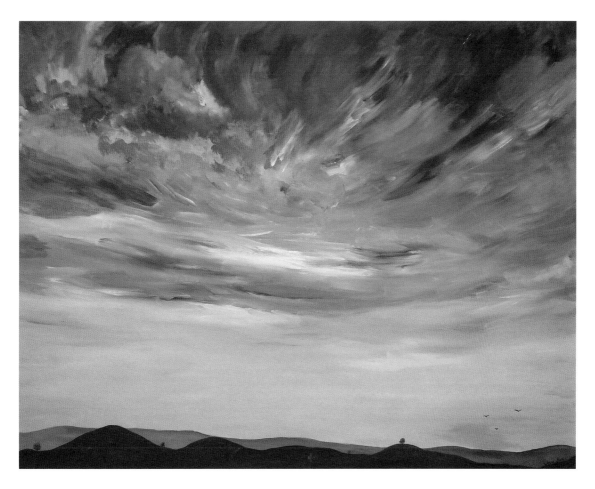

"Sunset over the Valley"

Sky

You're not the center of my universe
Although you are a major body in it.
Life with you's good, without you it's no worse.
You stole my heart, and now you have to win it.
You see in me a light, unfettered soul
And do not know how much you make me free.
Without you I am one, and with you whole.
I wish you were just what you want to be.
You reach out for the sea, up in the sky;
I count the stars while walking on the shore,
And if I ever have you closer by
We'll be all that we are, and so much more.
 And if you ever find you want my heart
 Then it is yours to take and make love start.

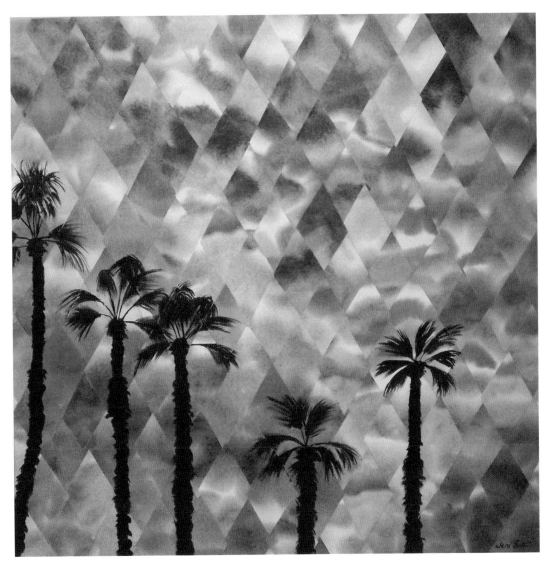

"Palm Springs Sunset"

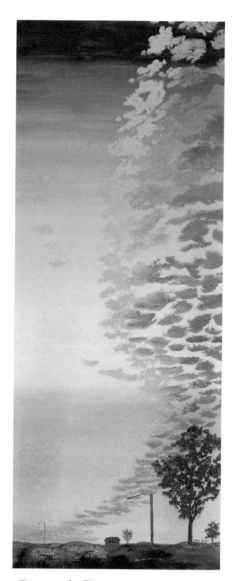

"Riverside Dawn"

The Color of Sanity

Sanity is as easy to define as any color.

Has your mind ever fallen off your rainbow
And floated through ice blue, azure, cerulean,
Away from foliage, earth, rock
Then you realize that you may be falling up
Away from the abyss, into the void
But the black, opaque emptiness is above
you again
And you don't know if your body is falling up
or down
But your mind is spiraling into itself without
ever arriving.

*Are you in a black mood, feeling blue, seeing
red,*
In the pink, green with envy, purple with rage,
*White with fear, puce in embarrassment, silver
tongued?*

Friends and family are passing you
in both directions or is it six directions
or is it a hundred directions

And they are shouting at you that flying is normal
All you have to do is flap;
You start to tell them that you don't have wings
But they don't understand, they all speak
In different languages now.

Are you brown-nosing the boss, have you got a yellow streak,
Are you peaching on your friends, rusty on some skill,
Fawning over someone, did you get emotionally marooned?

Slowly, with so much rushing speed and little movement
You meet granite.
Without time to question
If it was a chasm or an asteroid, you bounce,
Start all over falling again.

Are you being a wise sage or a plum fool,
Are you suffering from gold fever,
In a gray area, feeling a little off color?

As the colors of emotion and madness race by shining
Through transparent shards that are your jigsaw psyche
The only color with no emotion is orange
Maybe it is the color of sanity,
But even so, it is still a little fruity.

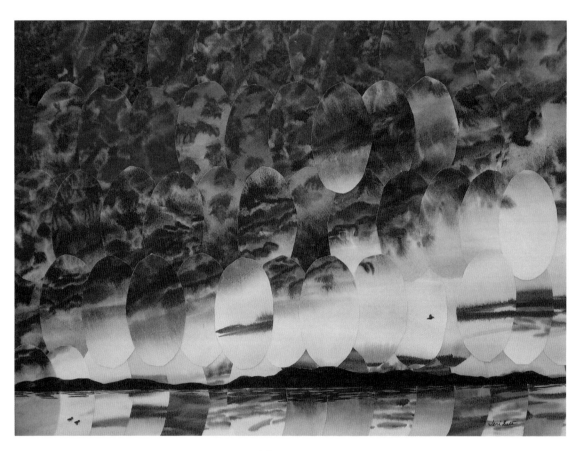

"Velvet Virga"

The Love Yard.

Here on the hill
Nowhere near a church
A tiny field with a tidy hedge
Mown fine like a lawn -
A graveyard.

Two rows
Bodies huddled together neatly
No more than four inches between
The back row dated 50s, 60s,
Moss covered and hard to read
The front row 70s through 90s,
Sharpened edges, clean writing
In Welsh and English -
Thomases, Morgans, Williamses, Bevans and Bowens;
Iaeuans, Glyndwrs, Annies, Margeds.

Beloveds, In loving memories
Never forgotten.

People laid under these stones
Were not dead,
They were loved.

They were not planted here in these holes
Because they were as cold
As the stones over them
But because they were mourned
They were missed,
They had left holes in people's lives
No one could fill with warmth.

This is not a graveyard,
This is a loveyard.

Here lies love,
Not just a body but
All the love we shared with him or her
Put into the ground after them
Because love, unlike life
Doesn't always end there.

We put our love in with them
And stones that will last as long
As we know how to mark time
So we know
Where they have gone
With our love
So we can follow after.

Rowing

I used to cycle up this hill, he told me
back when I thought I was immortal
before I had that meeting with the truck
and I realized I could die

I used to cycle up this hill
like the hill would go on forever
and I would go on forever cycling
but then I had to stop, start only running
and nowadays I don't run as fast

I used to cycle up this hill
and there was nothing in the world
that could hold me down, except my desire
to go screaming back down it
freefall on two wheels
a blur forgetting the need for brakes

I used to cycle up this hill
now I realize at some point the hill will stop
that's why I'm not moving so fast now
I'm not ready yet for that ocean view
that shore, that little boat

"Up the hill"

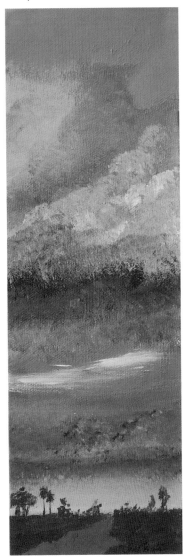

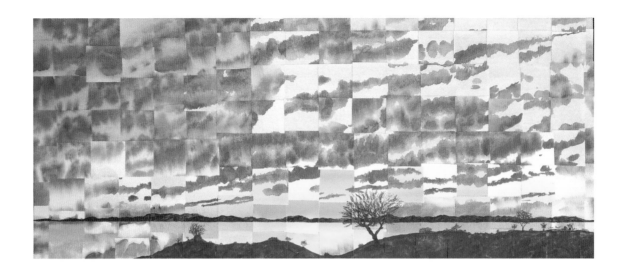

Because

when under his easy skin beat life
together as in blue worship
frantic music urges gone weak for rain
can chant essential woman elaborate power
light all shadow sweat he delicious why

(I found this poem amongst those little magnetic words on my sister-in-law's fridge.)

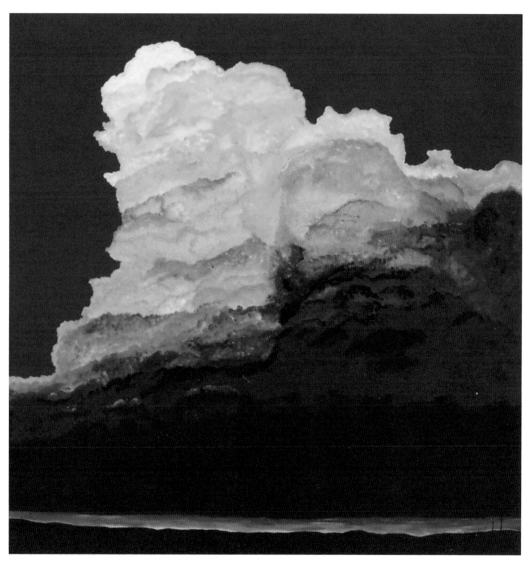

"August Afternoon"

Daydream

A wisp.

It started with a wisp which
Curled into a little curlicue
Then wrapped around and made
A puff.

A silly little puff which
Billowed into a tiny cottonball
Then pushed out a second lobe.

Now it is a baby cloud
Forming soft white mountains
Of water and light
Against the deep blue,
Folding and fluffing
Pillows in the sunshine -
An angels rest
For an afternoon nap.

Soon the castellations form,
Battlements in the sky
Turrets on a palace,

A city building, growing, populating
Then

Just as cautiously
Dismantling the creations,
Constructions unarchitecting
Melting into blue heat

Stones melt like snow lava
Boiled in its environment
Evaporating outcroppings
Into a jumble of pebbles
Worn down by the flow of water
In a river of time
Edges fading into cream
Then passing from mist to cerulean

Material becoming lace
Lace fraying, curling edges into air
Separating and dissipating

Thickness dissolving into thinness,
Turning back into water drops
And just before vanishing, flicking..
A wisp...

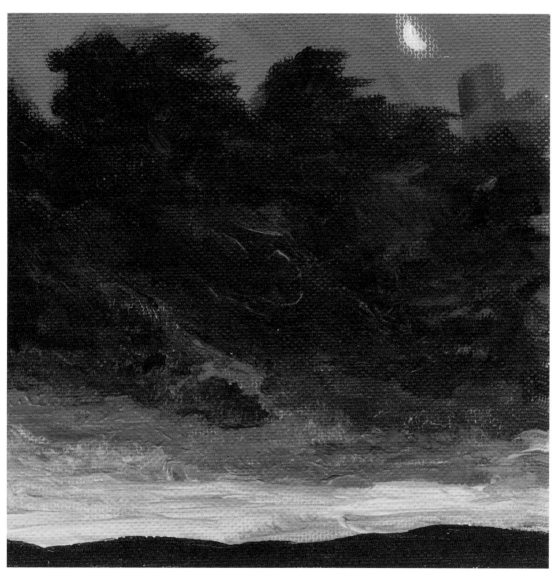

"Yellow Dawn, Waning Moon"

33

"Sea Crest Dawn XXVII"

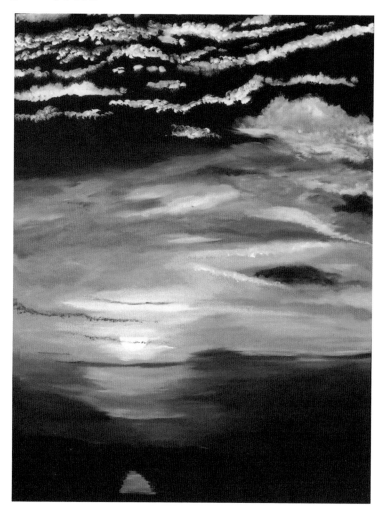

Geneen Estrada once asked in a magazine article, 'What is it that you collect?'
I'm not a 'stuff' person, but I do collect silences.'

Silent City

A hundred years ago, a river bled my ocean into the desert.
It lays there now, a southern jewel on the sand.

A city tried to grow there, but wilted in the sun
Until I found it, silently waiting for my noise-stressed heart.

I love those silent streets. My nearest neighbor
on the other side of a freeway of desert.

The roadrunner owns my yard, hummingbirds fight on the patio
Then call truce together on the washing line.

I can hear a car coming half a mile away, doves from further
And the flitting of the bird that nested in the porch eaves.

In spring, the mesquites hum with bees, in summer,
Most everything leaves town; I wait for the fridge

To stop purring, turn off the A/C, the fans, listen to my heart,
Beating to the silence of the desert, blood rushing in my ears.

But now my desert ocean city is growing. I will soon have neighbors
Where I once had a view. People, where there was peace.

Cars and sunshades for creosote bush and sage; gone will be
Scorpions, ground squirrels, snakes, birds, sunsets, silence.

6am men arrive to fiddle with concrete slabs they are planting.
Music from their cars shock us from bed like a six pointer.

Freddie on the front porch in boxers: My friend! The Music! Too
Loud!
I think: Shut up and listen to the desert while it's still here!

200 miles away, I write this on a workday at 6am. I still seek silence.
This city is as quiet as it gets; the freeway is just starting to purr.

The fridge rumbles and gurgles like a stomach about to vomit;
The lights whine a note beyond Freddie's hearing range.

The water heater sings songs fit for a pterodactyl about to explode.
It drowns out the sound of him sleeping in the next room.

The separation anxiety for my silent city bleeds onto the floor.
In a hundred hours I will be there; will I find silence?

I vow to walk the silent streets before dawn, before my city becomes a city.
Before the silence bleeds away.

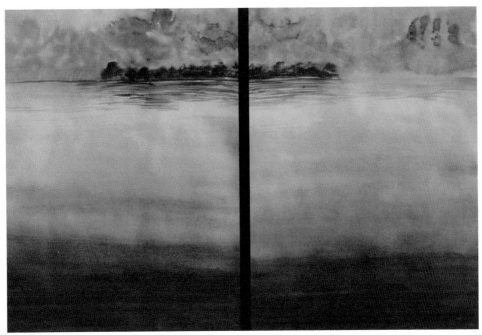

"Misty Morning II"

Homeland

I live in a land with a watery limit
A gray dull sea, with a duller strand
An expanse of mind with nothing in it
A limit to conscience that's always at hand

And if the tide is running high
Emotion ebbing fast in me
I take myself to the final limit
And take all stock of the limitless sea.

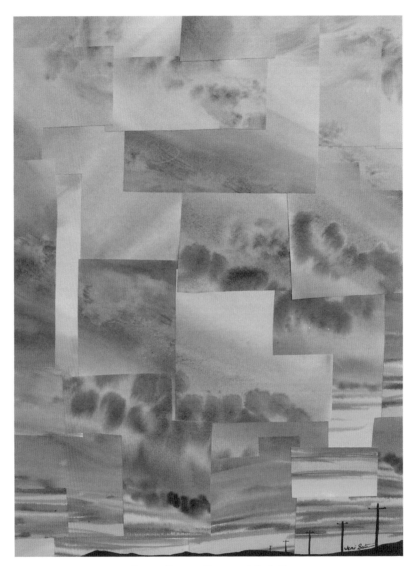

"Sea Crest Dawn XXXI"

Down the Wire

I wanted to say...

I called because I was thinking about you
And I was thinking about you because...
Well I was just thinking about you
And wanted to talk to you about...
Something other than the usual work stuff we talk about
Lets talk about ourselves, each other, us
Let's talk about the color of daydreams, about dreams
The meaning of time, the emptiness of time
The emptiness of night sky, the emptiness of arms
I want to hear your voice, I want to hear your heartbeat
I want to know when is the next time we'll see each other
And what we'll see in each other
And what we see in each other already
But maybe you haven't had a reason to call
Like we still think we need a reason to call
Well, I'm telling you straight, you don't need a reason

So call me.

Well, that's what I wanted to say....

But I could never leave a message like that.

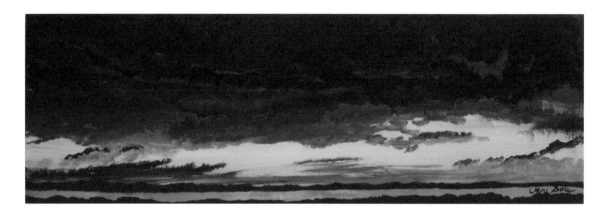

Falling

Shadows fade to light
Sun sinks like a sigh of day
Eastern clouds grow pink

Magic hour begins
Sun rims western puffs with gold,
Bronze, crimson beauty

Glass

So, he asked me,
is your glass half full, or half empty?

No.

My glass is half full of water
and half full of air
It is also completely filled with crystal light
and, as it is not as cold as the
absolute zero of interstellar voids
it contains heat - room temperature.

And yes, if you look at it, it also holds
the images of the room that it's in.
Plus, we have the meniscus, the way
the water creeps up the sides a little.
And then there's gravity
to hold the whole thing together.

It's amazing how we have all four elements here.
The glass is made of silicon and can represent stone.
Then, obviously the water and the air
the temperature, representing fire, however feebly.
All the things we need for life.

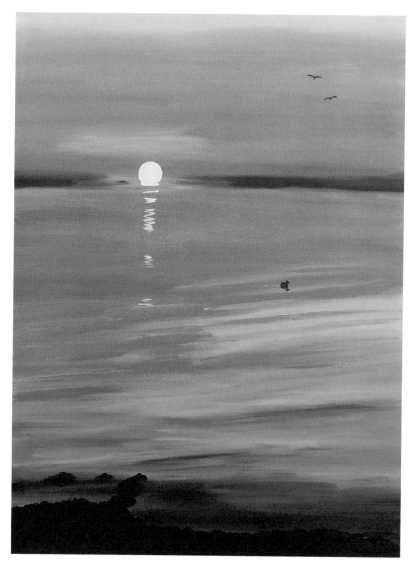

"Salton Solstice V"

Then there's the glass itself –
it could be regarded as a prison
or a cocoon.
It might be cut or blown, but is unlikely
to be stained, as that would imply lead,
Though it might be tinted or painted
or it could just be plain.
The shape and the weight of the glass
are also a factor.

Is the glass waiting to be filled or emptied?
Is it being drunk from or filled at this moment?
Is it held or set down?
Has it been knocked from the coffee table
by the wagging tail of a big happy dog
and is about to be shattered?

In any case, the real glass in front of me
has just been drained
of its last drop of whisky
so I'll get a refill
in the hopes that your glass
is as overflowing as mine.

Rose Water

Inside my
inside my
inner pool was calm
before your storm
stirred up silts
I had never known were fertile
becoming the primordial
suddenly you were not
just the god saying
let there be this life
but letting me read
your words myself
until I cannot hear anything
but your cadence
on my lips
tasting your skin
for the first, every, could be last
time where dreams and poetry meet
my pool dancing
under your sky vault

my loam roiling
suddenly filled
by something not-I
the ultimate joy beyond-I
for I of I with I
inside my
inside my
inside your pool I cry
the last blood tear
from blinded eyes
into you, turning you
from spring crystal
and your own painting
psyche dancing dirt
into a single sudden
profound mystic rose.

Come grow in my garden.

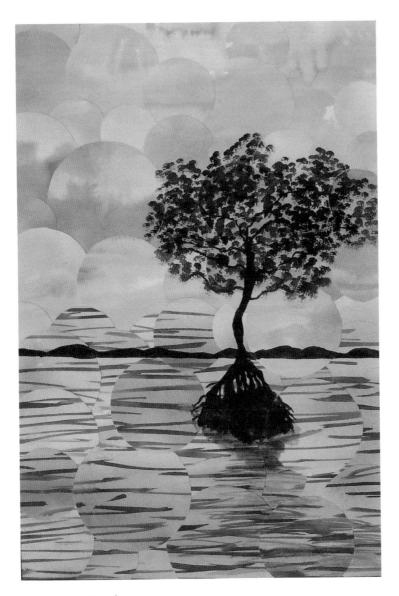

"Lagoon Dusk"

Eclipse

as sky and sea and land
merged all in one
with darkness
filling the air
there was no sign
of life
there appeared no evidence
of fear
there was reek in the air
and the stench of death
in some nostrils
there was only despair
throughout the world
where darkness grew
silence ramified voices
like there was no language
things turned and walked alone
to await the time
only patience was required
before this second dawn of the moon

the world should wear a shroud
of fate and miscomprehension
the extent was unknown but widespread
and it was unseen by an outsider
this sudden relief when the end was over
and going back to the beginning
was a slow process
like this punishment
for crime unrealized and unintentional
is no less real and irreversible
an experience such as this like life
might be needed in the eternity beyond kings
to realize the beauty of its symmetry
it must be observed with real eyes
for there only can be seen
the world relaxed unharmed reemerges
as sky and sea and land

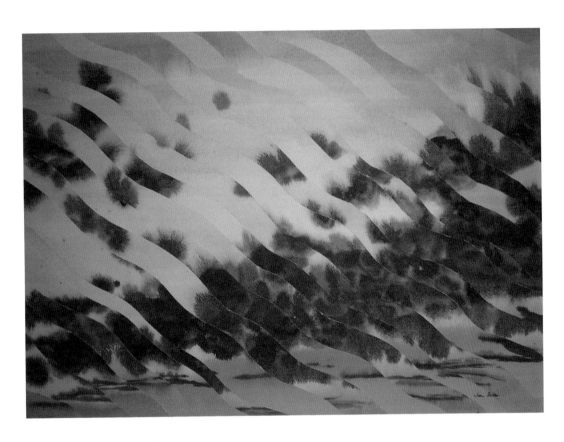

"Earthquake Weather"

("Eclipse" is a circular, alternating poem. Each line makes a different phrase when matched with the line above or below it. Also the last line wraps around to the first.)

He, sleeping

He, sleeping,
is given to me
in pre-dawn colors
soft as his kisses
deep as the forest green
under which he lies.

He, sleeping,
is beauty painted
on the canvas of my life
a color that I could never
reproduce, it is
beyond rainbow splendor
or all the hues of sky
and just as untouchable.

He, sleeping,
is something for which
I would hold my breath
until I were as gray
as the light which
clothes our eyes
and our dreams together.

He, sleeping,
does not face me
with a face closed
presents a back I can stand or lie against
shoulder strengths
curved together in caress
for which I wait.

He, sleeping,
and on the brink of waking
blinks and sighs
turns to hold me
disturbed by the dew
that fell on him
from my eyes

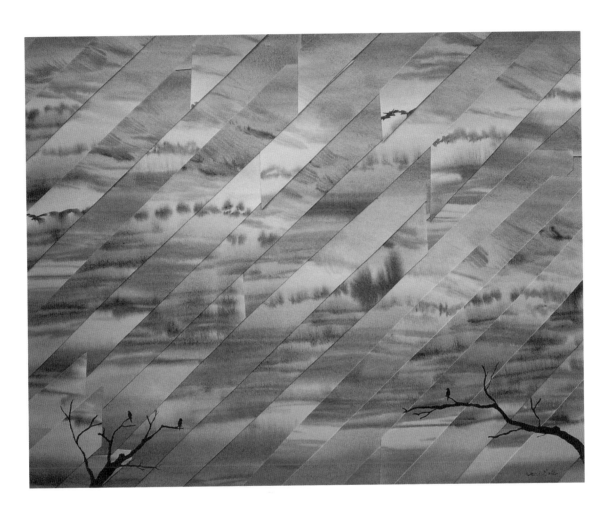

"When the Morning Comes"

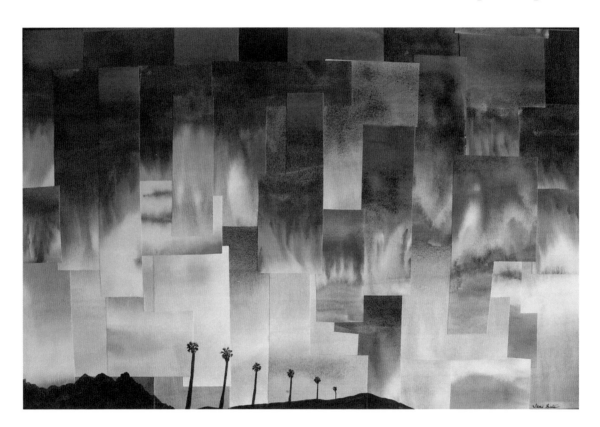

Home made Stew.

Shall I compare thee to a home made stew?
You are both full of lots of nice surprises,
Agglomeration of the things you knew
Of things that come in different shapes and sizes.
Your mixture is a vast experience
Of things that would be nothing on their own.
The stew is cheap. You're not high maintenance
And you're both waiting there when I come home.
Each day you'll both have something added to
And each day also something taken from;
Always yourself, yet ever something new.
I know I'll miss you both when you are gone.
 You're spicy and your juice is always hot
 Not from a book, but good to the last drop.

Capture

Clouds race over the sky
as in some mad escape
as the nearby hills
seem to creep inwards.

Trees stand gray and naked
shaken by the wind, playing possum,
the houses stare fixedly forward
some cross-eyed, some low-browed
and continue blowing smoke at the sun.

The hills are coming nearer
pretending badly that they're not trying
to engulf the floodplain.
Menancing like slimy creatures.

Angels are singing somewhere
but their voices flee with the clouds.
The sun retreats from the trap.
Maybe this is just the center,
maybe there are more rings outside.

"Away we go"

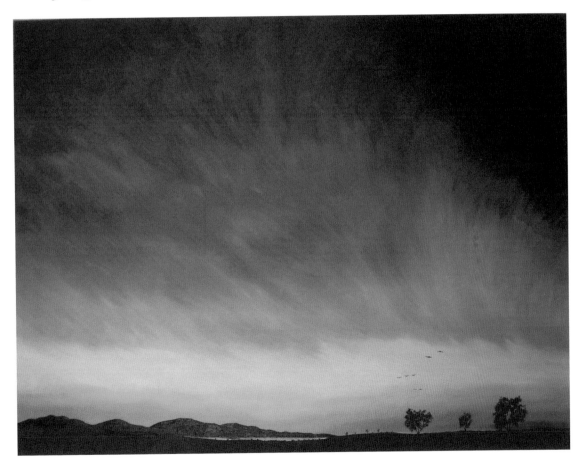

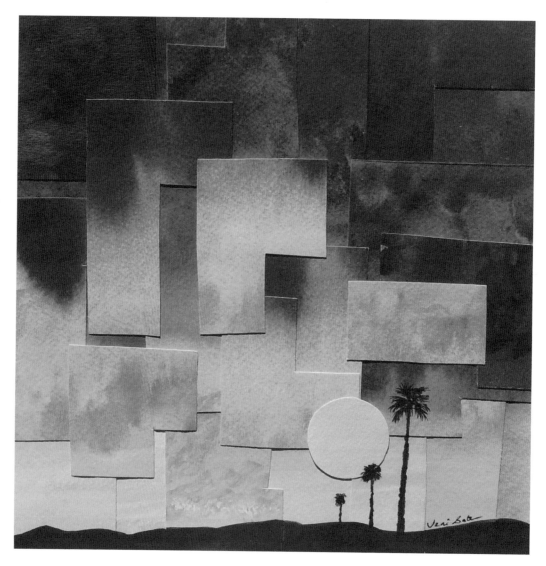

"Desert Dawn"

At Dawn

I love to watch you sleep
the frown relaxed out of existence
your lips stilled into a fullness
they never seem to find
when curving words into the air
your lids calmly row on row
of soft thick lashes
gentle enough to
brush away nightmares
your breathing easy water
lapping at a quiet shore
your hands more yielding
than when you touch me in love
and your mind somewhere
I can only want to follow.
And then
and then, this is the best part of all,
you wake
and bringing me your smile
and sometimes,
just sometimes
your dreams.

The Song of Crickets

Afterwards, I lie awake
listening to the song of crickets
a dinner party in the apartment next door
the tv below
and this poem being written in my head

over the hill
the circular breath of traffic
from a thousand metal hearts beating
and iron lungs
that exhale smog

somewhere a jet growls goodbye
and the moon and wind and trees
play a silent movie of shadows
on the closet door

you breathe, I breathe ...
you breathe, I breathe ...
you breathe, I breathe ...
and we do not dream in this moment
but lie awake listening

to the song of crickets
and the constancy of our hearts

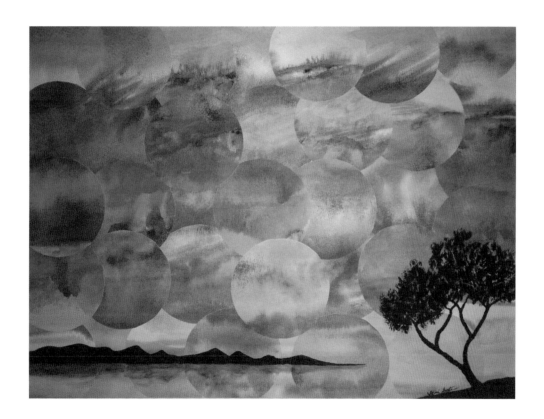

"Tranquility with Tree"

Discovery Chanced

It seems so precious that I tremble here
held in your arms, and rest against your heart
so rare, because we're born so far apart
divided by both distance and by year.
I shake with wonder at what we have done -
to find each other across that dual void
and doing so, fear being overjoyed
lest laughter rends apart what love begun
in seeds of nothingness. I touch your hand
and shudder at the lack of space between
against the miles for so long there has been
that slipped away like grains of falling sand.
 And what gods should we thank we're not alone?
 We couldn't have found each other if we'd known.

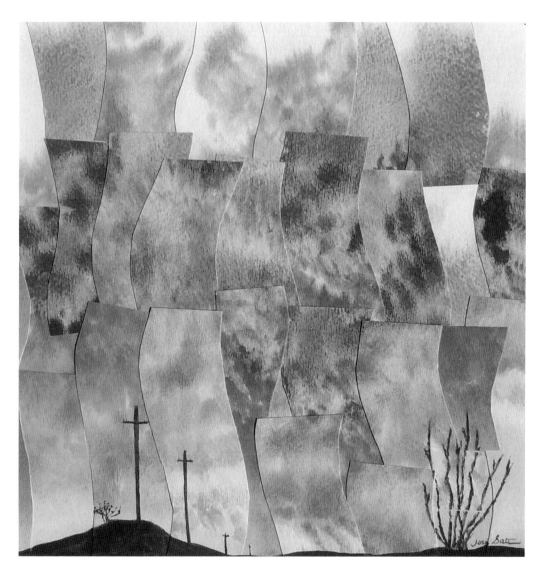

"Dawn Fire"

Death Row

At first glance
it might seem,
that being a fighter pilot
or a mafia nobody
are the most dangerous occupations,
but according to statistics
being a poet
is more lethal.

The suicide rate
is twenty times that
of any other job.

Maybe this is because
that which makes us poets
is the ability to experience
Everything
in about twenty dimensions
rather than the usual three or four.

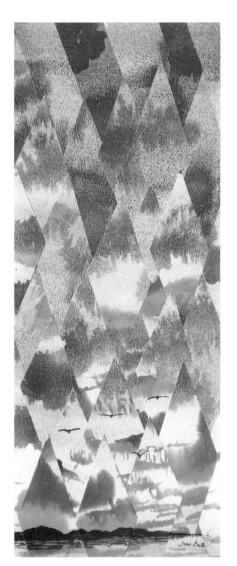

"Four Crow Morning"

And the stress of having
to get those feelings
into monochrome words
on a flat page
or hanging one-dimensional
through the air, spoken,
or not having the right words
in any language
like trying to paint the whole world
using only the colors of the rainbow.

Even when we have the words -
capturing an approximation,
then these other mortals
that share our genetics
only enough to breed
simply don't understand
and walk away
leaving us hanging
or bleeding
from wherever their sharp silence cut.

Gordon's Song

I remember the morning I first realized
you were fading.
Someone over the hill was beating a drum -
it sounded like your heart.

And still, down the wire and through the air
we laugh and joke -
the habit of creatures who still believe
they have a future,

not just a past to live again and hold
voices like hands,
as if the miles, a continent and time and fate
did not divide our lives.

And now you're just an echo in the chambers
of my memory.
I am a drum, empty and hollow, and hope,
a beautiful reflection of you.

I remember the morning I first realized
you were fading.
Someone over the hill was beating a drum -
it sounded like your heart.

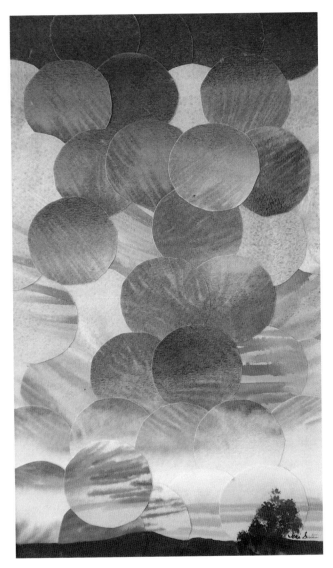

"Tomorrow's Road"

Hey Sunshine!

Why are you sitting there with a heart
As blue as the clear sky?
Just because your soul is as deep
As the ocean, doesn't mean
You need to go all the way to the bottom.
You could throw out a line - do you need bait?

Or maybe you would feel more sure
On the shore
Where your feet will only sink a little
Into the dust of Midas,
And if you walk close to the edge
The depressions will soon be washed away.

Did you ever notice as you walk down to the water
That it is so happy to see you
That the whole ocean waves hello?

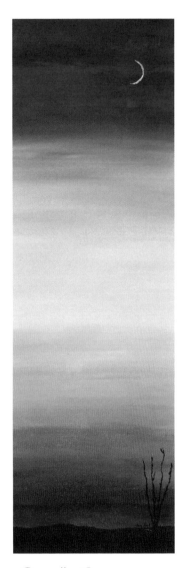

"Ocotillo Sunset"

And as the sunshine pours, as red as molten steel,
From the blue into the gray
The moon rises up, sometimes splintery,
Sometimes not at all
And sometimes howling-round
And full of tears
To taunt you that it can still see the sun.

And I know your sun smile rises and sets
And your moon mood waxes and wanes
And your emotion tides ebb and flow
But the stars rarely change
And there is a whole universe out there
To hold on to
And the whole of our lives
That pass in the blink of its eye
To wonder at it.

And if each star, each pinpoint, is a blessing
They are all so hard to see
Until the sun goes down.

You said.

You said he didn't leave in the morning
but instead in the afternoon.
No reason, no message, no warning.
Didn't say if he'd be back soon.
You said that if he came back
you wouldn't have him back
So why did you cry if he's leaving?

I know that he said that he loved you
I don't know if you felt that too.
No fights, but there must be a reason
why he felt that the thing was through.
You said that if he came back
you wouldn't have him back
So why did you cry if he's leaving?

You said that you would've known
if there was another that he'd go to.
No suspicions, but he still left home.
I don't know what to say or do.
You said that if he came back
you wouldn't have him back
So why did you cry if he's leaving?

And perhaps it's the reason he's gone.

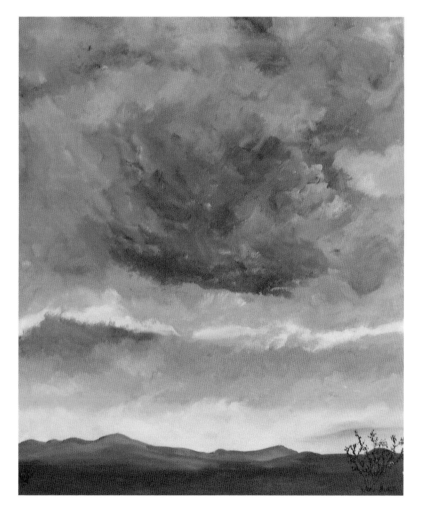

"Storm at Sunset"

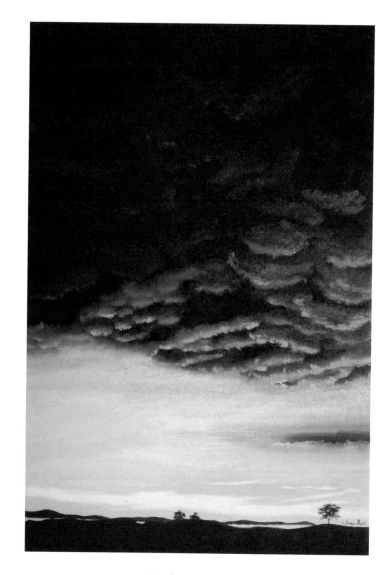

"…. And Never Leave"

Mantra

Go home
take off your shoes
wash the grime of tiredness
from your body
wash the pain away
it's been so long
since you stopped
since you stopped being Atlas
bearing the sky on your shoulders
since you stopped being Eve
bearing the human race
through your anatomy

don't say words you'll regret
don't say you'll go on anymore
don't say anything
ignore the phone,
the doorbell,
the mailbox

the world that is your cage
escape to who you are
or who you want to be
or someone who isn't you any more

let go, let it be, let the gods
take over your nothing
the black hole that this all
did not disappear into
but evaporated from
no one else can do this for you

let the stars guide your steps
let the moon light your way
let the sun warm you
be elsewhere, empty, content
be yourself, alone, reborn

Rises

The darkness roils
A glimpse of moon sliver shows
Hovering water has occluded the stars.

Light waits, the world rolls on
Unpausing in its creation.
Shades of grayness are revealed,

Grips and scatters of darker
Against lighter softness, with a subtlety
Of the blueness that makes the ocean.

Waves crest and the tops
Fade into cherry foam;
The deeps hesitate into surrender.

Scarlet rises, pushing crimson
West into yesterday.
Clouds lace their edges for adornment.

Frills appear where blandness was,
Rills and ruffles, reds and oranges,
Fingers and reaching tongues of flame.

The hot coal of horizon
Glows angry yellow, spitting up
Into white hot underbelly slices.

The inferno approaches
Roasting each cloud into bronze
Then fading to gold and silver

As last night wisps into today,
Ochre chasing cadmium from the palette,
Western crimsons washing into blue.

The sun rises.

"Painted Dawn"

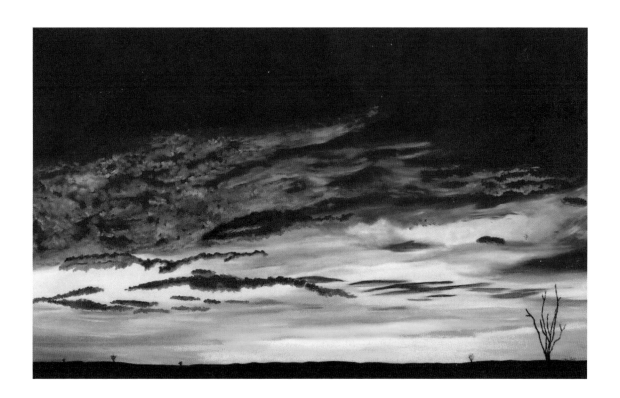

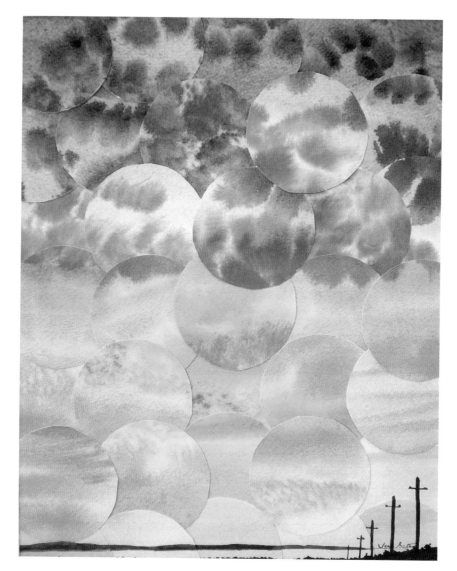

"Sun-Up"

72

Big Bang Practical

I never understood the galaxies -
The way they whirl, the many stars they hold
Or why the space between is oh so cold
With emptiness, your last breath wouldn't wheeze
Out from your lungs, they would just tear apart.
I never understood the universe
The way it says so much, yet is so terse
Or how it knows exactly when to start
From nothing, and to grow and never stop
At all. And then I loved you. Not one drop
Of time falls, but love spills out from my heart.
 I comprehend the universe much more
 Now love's star's twinkled in my heart's own core.

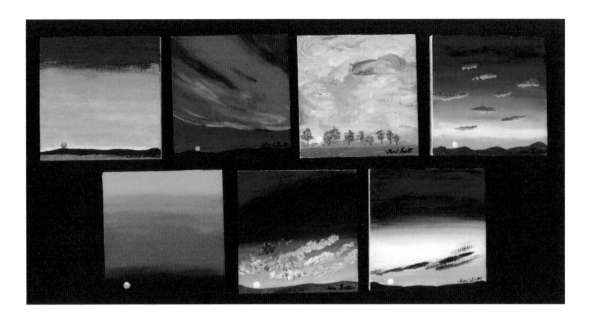

"A week in Politics".

Individual panels are named: The day before that, The day before yesterday, Yesterday, Today, Tomorrow, The day after tomorrow and The day after that.

The thought behind this is that whatever we do in the world, the sun is still going to come up tomorrow. I suggested to the buyer that they could move the days around on the hanging area, giving an infinite variation on the week.

Re: 'Money is Everything': Robert Wynn once said he believed all poetry had one thing in common - that the poet believes what they wrote. Oh, red rag to a bull!

Money is Everything

Love and laughter are wonderful things
But neither one pays the bills

You can be as beautiful as you want to be
But it doesn't beat having skills

You can have a body like a god-made angel
But clothing is still required

You can do your job as good as anyone
But it don't mean you won't get fired

You can smile worth your while when things go dead wrong
But a smile doesn't change the facts

You can be so meek you'll inherit the earth
But think of the inheritance tax

You can be so positive you'll succeed
But it doesn't beat plan B

And if you think money isn't everything
You can give all yours to me.

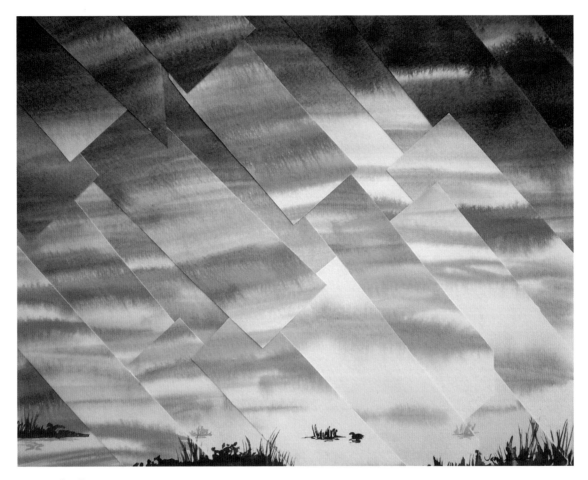

"Marsh Storm"

Synesthesia is an effect in the brain where the person may see numbers and letters in color, for example. I also hear voices in color.

The Tones of Eggplant

I have never been so enamored
with the sound of a voice

the color of eggplant
deep shining and mysteriously opaque

a soothing dark wave
timber without edges

wizardly protection from dishonesty
roiling knowledge

would bless any language
if love never touched it

would tint adoration into
the last shade of sky before nightfall

my ears yearn for your speech
even the dusky purple whisper

that sometimes hints in my
earlobes, shell-like and waiting

for your next word.

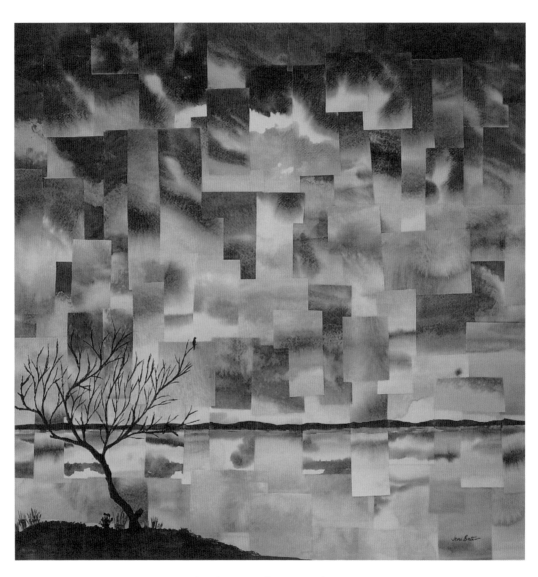

"The Best is Yet to Come"

Rain

I lie awake in the warm darkness
Listening to the silences
Between my heartbeats,
Praying for rain.

Pit.

A storm was promised
In the night
I do not want to miss it
By sleeping.

Pit.
Pit-pat.

Is that a twig blowing
Across the roof?
The tree moves restlessly
The wind is coming.

Pit pat.
Pit. Pat pat.

A distant rumble.
That is not an earthquake.
The wind froths the tree,
Shaking off leaves.

Pit pat.
Pat pit pat patter patterpatterpatter

The crescendo against the roof
Energizes me
Joy is rain, rain is joy
The desert gasps a welcome.

Patterpatterclatterpatterclatter

I cannot resist
I dress and go out
Hard fast water hits me
Cold and stinging

Flash.......Braaaammmmm

The storm moves closer
I dance on the back driveway
Tripod under the car porch
I open the shutter

Flash..Kaboom

Yes, I have caught lightning
Reset...
I twirl in the water
Gooseflesh rising

Fla-Bang-ash

Lightning hits a block away
Rain intensifies
Hitting so hard it bounces
I seek shelter, shivering.

Flash.... Grraaarrrr

Moving away now, I capture
One last strike
Gather up the camera
Retreat to a towel.

Drumdrum drumming

The power is out
I dry by flashlight
Get back into a still warm bed
And enjoy

Drum. Patter patter. Patter.

Storm retreating to the east
The scent of wet creosote
Rain receding to drizzle
To drops. And sleep.

Patter. Pat pat.
Pit.

"Coffee Bean Morning"

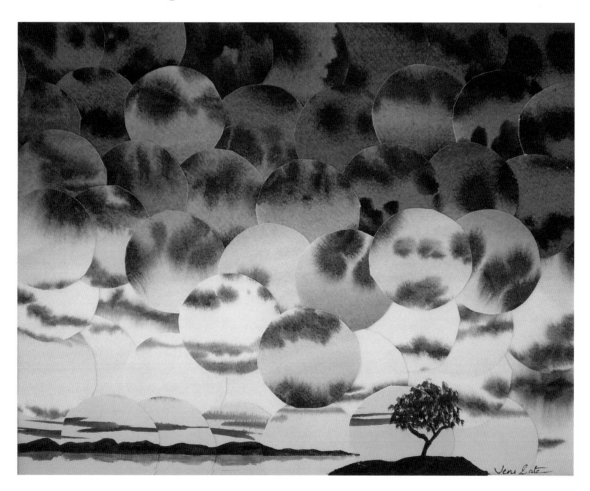

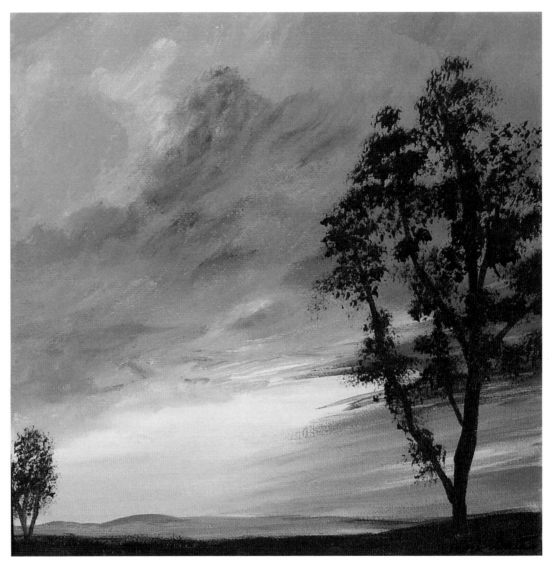

"The Road to San Diego"

Relife

I will take your face and stature, if you do not care
And force them to walk on long forgotten roads
In the long ago velvet folds of my green moss mind.

I will take your hand and stand by you when you're there
We will hear the cuckoo's call, not the caw caw crow,
We may see all the all and not be timeways blind.

We may walk in the fields and meadows, daisy-white
In the morning, and in the cool woods at the height of noon
We may drink from the silver pure stream all it may allow.

We may look on all time, and see the paths that are right
And take them, not the ones that made us part so soon.
Then I will not be here to write this now.

Artist Statement about Paintings

The aim with my paintings is to create joy in a world of stress. My emphasis is on the sky and the beauty that it can create at the edges of the day. Each dawn and dusk has the same ingredients, air, light and water, yet each day the recipe is different.

Most people will enjoy a beautiful sunset, and those that rise early enough, a beautiful dawn. Whatever else is going on, we often stop and look at the sunset for a few seconds, and think, "Wow, that is beautiful". This moment is a view to take you away from that day you had, or need to face and into a feeling you would want.

My intent is to capture such moments, and feelings, and bring them onto the canvas to be enjoyed for years. Many viewers express a feeling of peace on viewing my skies, which tells me that I have succeeded in capturing the antidote to the stress of 21st century life. The sky is an artwork available to every sighted person on the planet, and appreciation of my views transcend age and culture.

I was once told that the Romans believed that the hour before sunrise and the hour after sunset were holy hours, set apart and different than the day or night. Oh, my Roman heart!

I work in a variety of mediums - shown here are oils, acrylics and watercolor collage.

Some of the paintings shown in this book are still available at the time of going to press. If there's one you fell in love with, check for it on my website - www.skyscapesforthesoul.com. If the sunset or dawn you love is on a computer or a photograph - I do commissions, and love the opportunity to bring a sky I've never met to life with a brush.

Jeni Bate

Made in the USA
Charleston, SC
05 May 2013